THE OTHER

COLORADO

# ANIMAL SKETCHING

## By
## Alexander Calder

**Third Edition**

DOVER PUBLICATIONS, INC.
NEW YORK

Published in Canada by General Publishing Company, Ltd., 30 Lesmill Road, Don Mills, Toronto, Ontario.
Published in the United Kingdom by Constable and Company, Ltd.

This Dover edition, first published in 1973, is an unabridged and unaltered republication of the third edition of *Animal Sketching*, originally published by Bridgman Publishers, Inc., in 1929. The present edition is published by special arrangement with Sterling Publishing Company, Inc., 419 Park Avenue South, New York, N. Y. 10016, successors to Bridgman Publishers.

*International Standard Book Number: 0-486-20129-5*
*Library of Congress Catalog Card Number: 73-75876*

Manufactured in the United States of America
Dover Publications, Inc.
180 Varick Street
New York, N. Y. 10014

# ⸜ CONTENTS ⸝

There are two processes gone through in making each stroke of a painting or drawing. First, the eye and the brain, or the brain alone, must act and determine what it is desired to place on canvas or paper. This is a mental process. The second process is physical, for the hand must so control pencil or brush that the desired effect may be obtained, that the image the eye has carried to the brain may be correctly transmitted to canvas or paper. An artist may do great things after he has mastered one or the other of these processes, but he cannot achieve real heights with only one of them at his command. He must see and conceive things and also be able to execute them as he wishes.

There is no better way to master the two processes than to learn them simultaneously. The desire to draw something is the best incentive to make a drawing. But the mere thought "I must make a drawing" is no more an incentive than the thought "I must write a book." The desire to draw something is engendered by a condition or fact that of itself interests one, whether he can draw or not, or whether or not the thing to be drawn is difficult of execution.

The earliest men of which we have any record, thousands of centuries ago, expressed their sense of beauty by leaving pictures drawn on their cave dwellings. These pictures are for the most part of animals—of deer, mastodons and wild horses.

# ⸙ ACTION ⸙

ANIMALS—ACTION. These two words go hand in hand in art. Our interest in animals is connected with their habits, their food, the animals they prey upon or that prey on them, their habitats and protective coloring. Their lives are of necessity active and their activities are reflected in an alert grace of line even when they are in repose or asleep. Indeed, because of their markings many animals appear to be awake when they are sleeping, and many mammals sleep so lightly that even when apparently asleep they will move their ears in the direction of a sound that is inaudible to us. A deer sometimes will move each ear in a different direction, catching two warning sounds. So there is always a feeling of perpetual motion about animals and to draw them successfully this must be borne in mind.

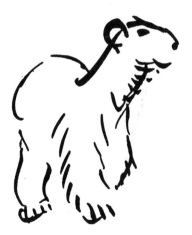

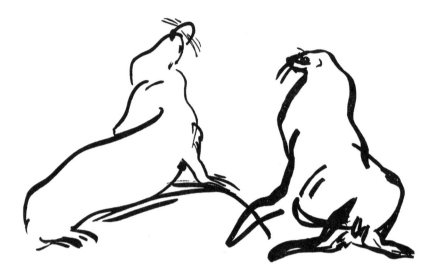

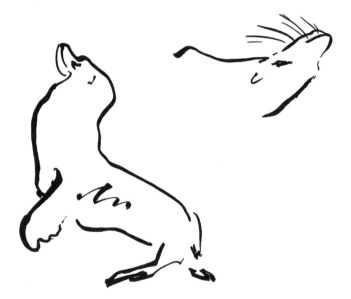

# ◢ RHYTHM–SEALS ◢

It would be hard to find a better example of consummate grace than the seal, or a more difficult model for the artist. The mental and physical processes of which we have spoken must be in perfect coördination in order to transmit even something of the extravagant rhythmic movement of this graceful animal.

When an animal is in rapid motion, or moves so that you do not expect it to return to its original position, leave what you have drawn and start a new sketch. Use a large sheet of paper and make your sketches small. You must work quickly and it saves much time in changing with the animal's movements. Do not trouble to have your drawings right side up or sequential. Keep rapidly transmitting your impressions of the animal's movements, and enjoy what you are drawing.

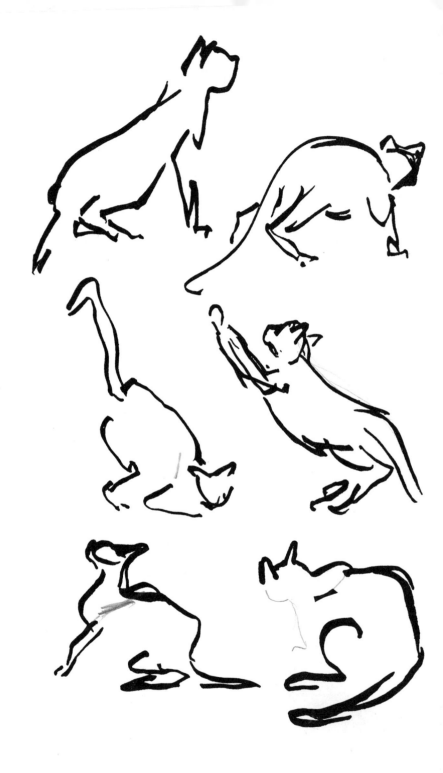

Remember that "action" in a drawing is not necessarily comparable to physical action. A cat asleep has intense action.

Cats, incidentally, make splendid models. The feline looseness and flexibility of limb have more grace in them than the more jerky movements of some other animals. One can almost see what a cat is thinking about.

If a cat is asleep, make it completely, luxuriously asleep, the belly supported by the floor, legs limp, muscles sagging. If it is alertly awake, get the attitude; all the muscles tense, ears erect, eyes observant, tail poised to give the best balance for a sudden spring.

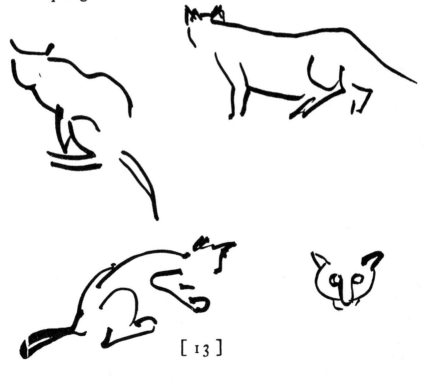

Side by side with the "action" of the animal goes its identity. For instance, if we are making a drawing of a dog it must have at least an indication of the precise breed of dog we are drawing. This feature of the drawing, the portrait element, is quite as essential as the other. It entails more intimate study and knowledge and can be attained less by that rapid drawing and recording so essential to the action phase.

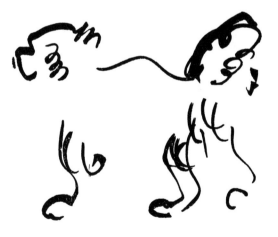

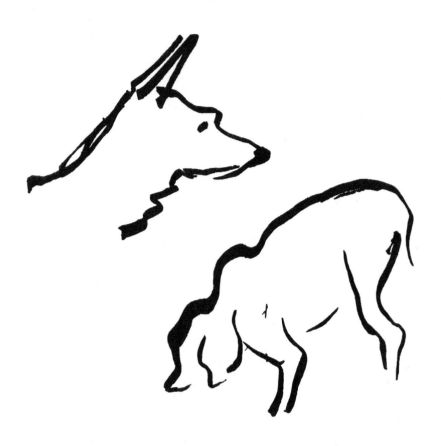

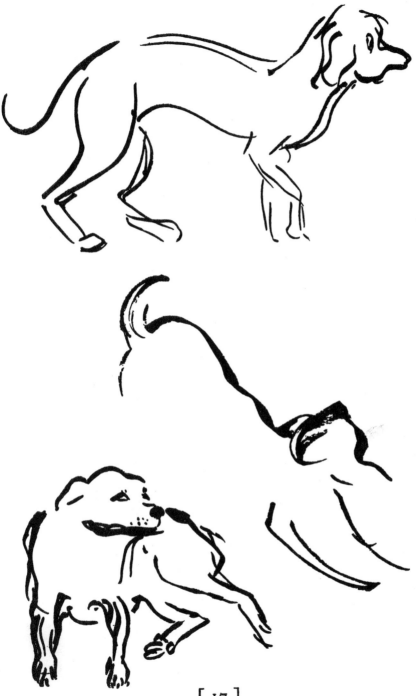

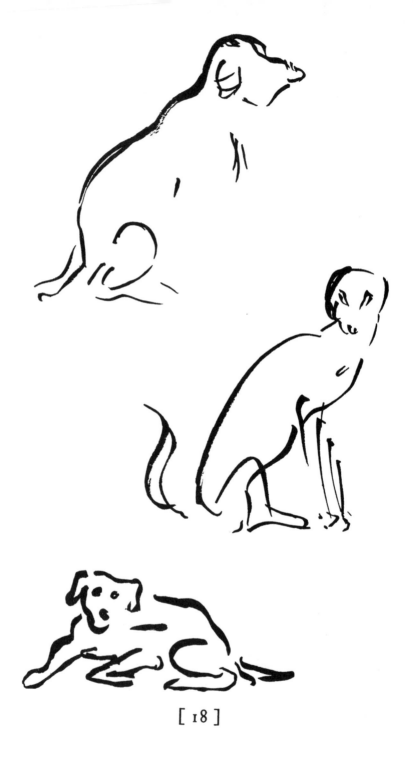

[ 18 ]

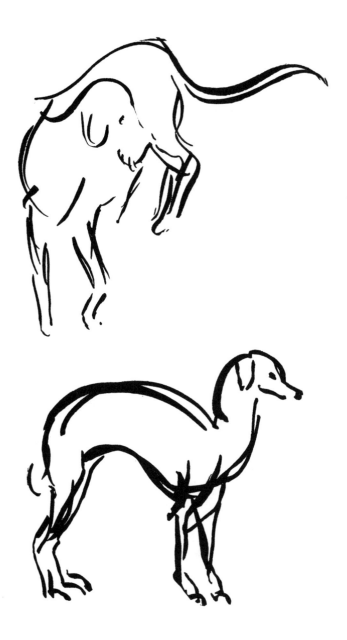

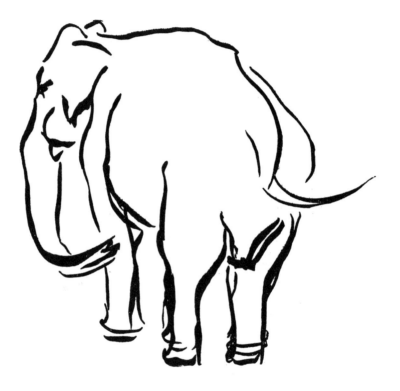

# ⸀ THE ELEPHANT ⸀

The elephant has been adopted as the emblem of one of our great political parties for a number of reasons. It has a sagacious profile and a cunning eye and its loose skin and paunch suggest the clothing and figure of some of our well-known politicians of bygone days. But the elephants we are most likely to see lead most sedentary lives, having gone "soft". Yet there is about the movements of this greatest of living mammals remarkable grace and rhythm. It is capable of terrific ferocity and speed when aroused. Study the elephant, if the opportunity presents itself. You will find it a fascinating subject and, perhaps, a far more beautiful one than you at first realized.

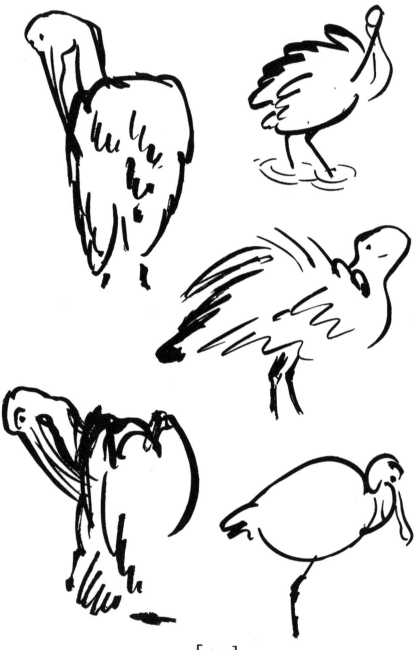

# ⁊ BIRDS ⁊

As a rule it will take many rapid sketches
of a bird in motion to get one that correctly
records the action, but one such drawing is
worth the trouble. The pelican swallowing a
bit of fish, the goose preening its feathers and
the introspective owl waiting patiently for
the night—all are difficult but worthy sub-
jects.

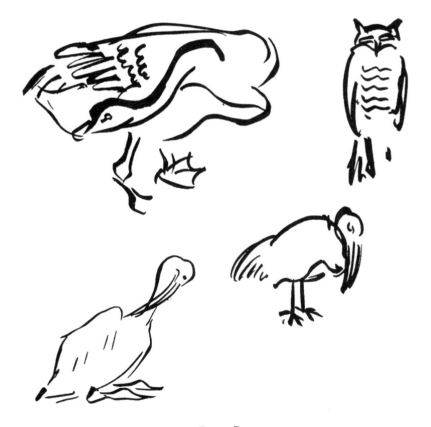

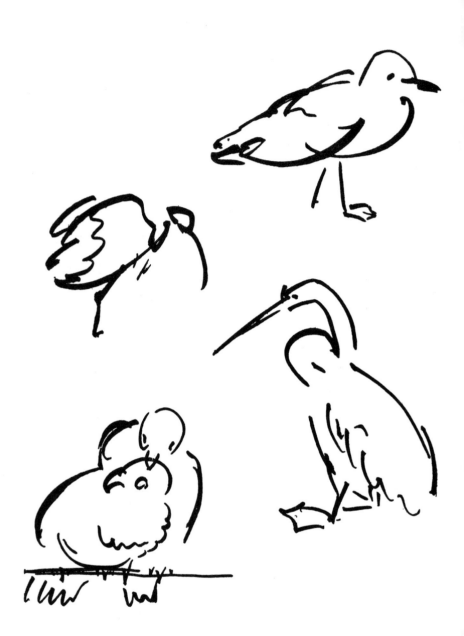

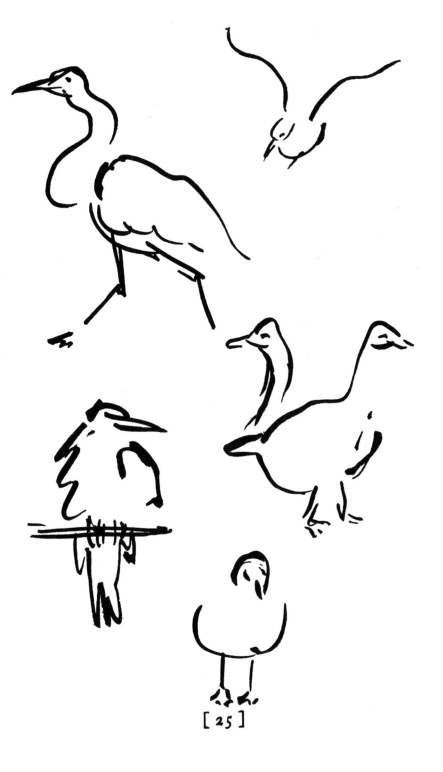

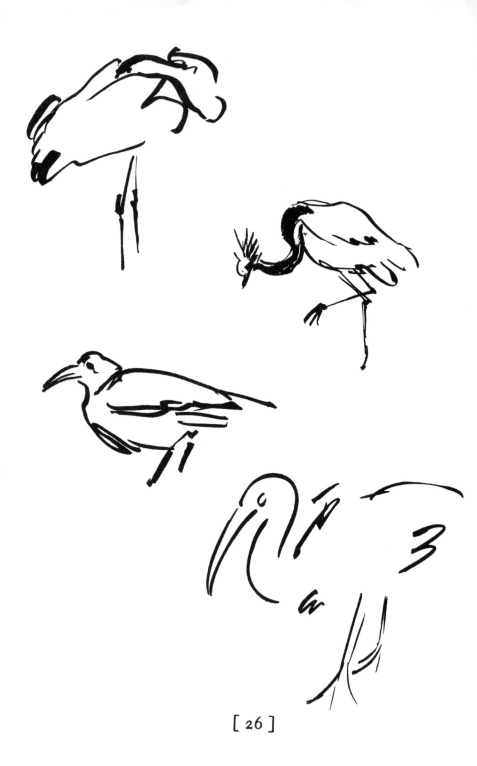

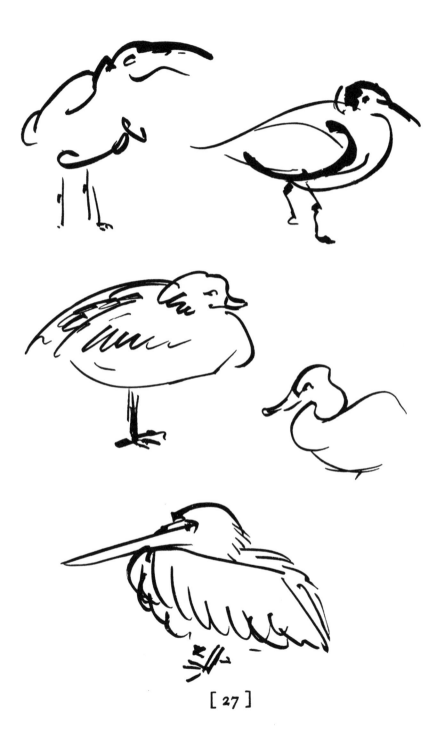

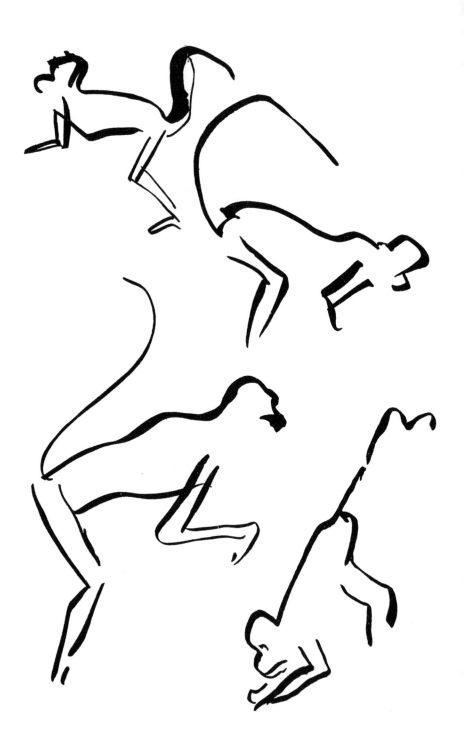

# ⸙ MONKEYS ⸙

All actions of every animal tell us what they are like in the native state. If we can suggest some of these things in a drawing we feel elated because we have really "got" the beast. Therefore in drawing the monkey we feel the necessity for a feeling that the monkey is doing something, no matter how simple or commonplace that may seem in itself. As a matter of fact the monkey is an exceptionally good example for caricature.

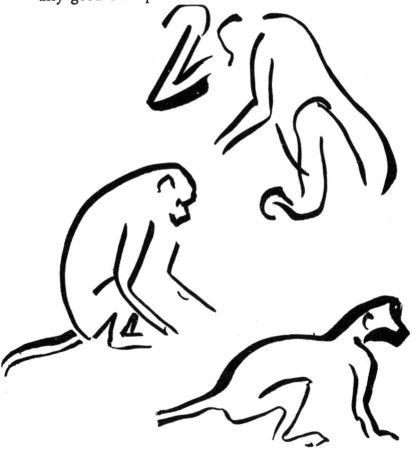

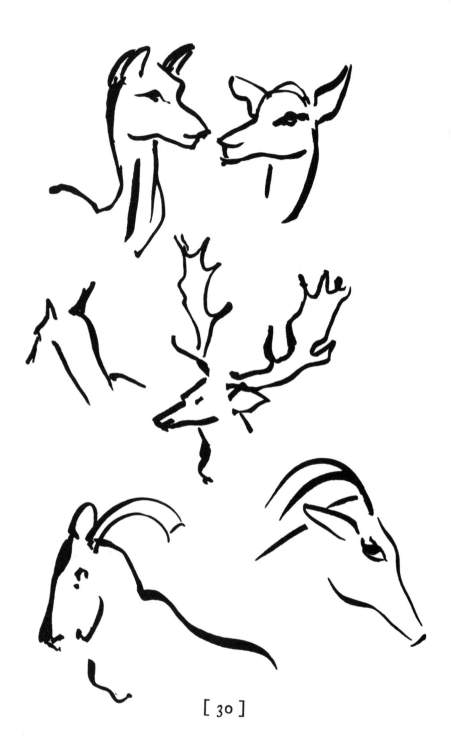

Probably of all animal families that of the deer family is the most interesting. There is a certain beauty not only of body, but of poise and femininity that appeals strongly to the subconscious protective instinct of mankind. The deer appears to be totally inadequate as far as self protection is concerned. Nature, however, has been generous to the extent of coloring and speed of hoof. Alertness and grace are probably the noticeable traits to portray in rendering when sketching the deer family.

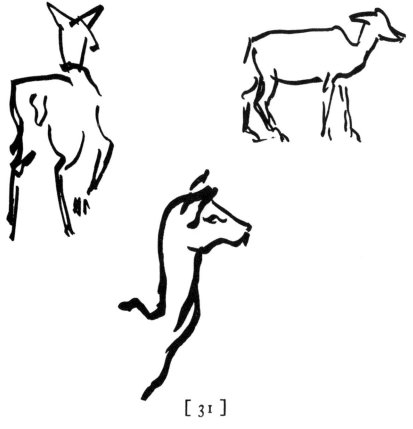

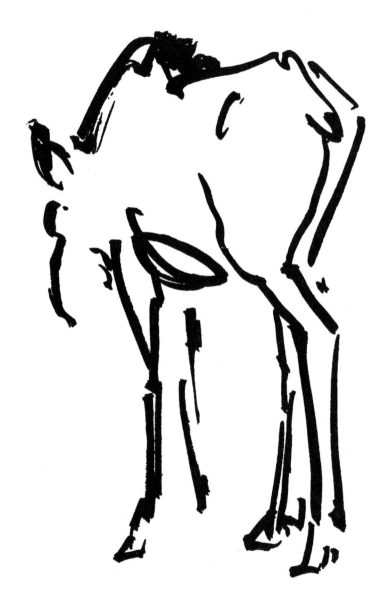

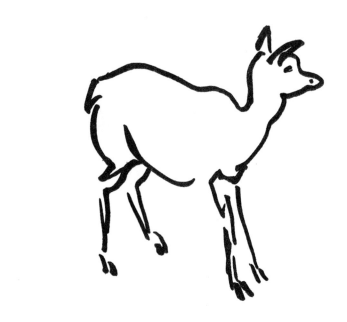

[ 33 ]

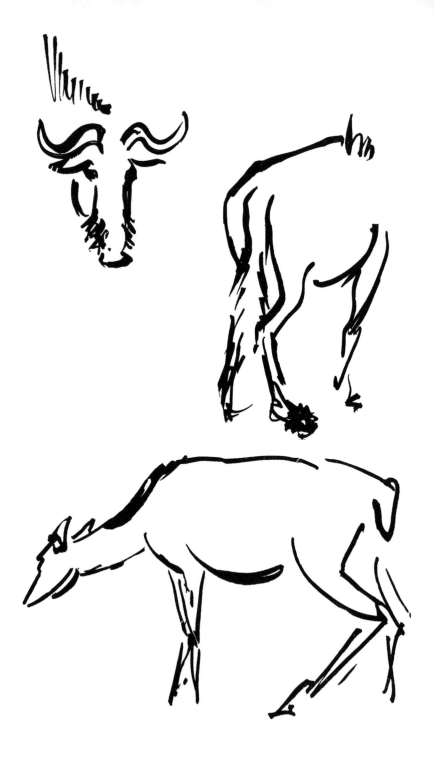

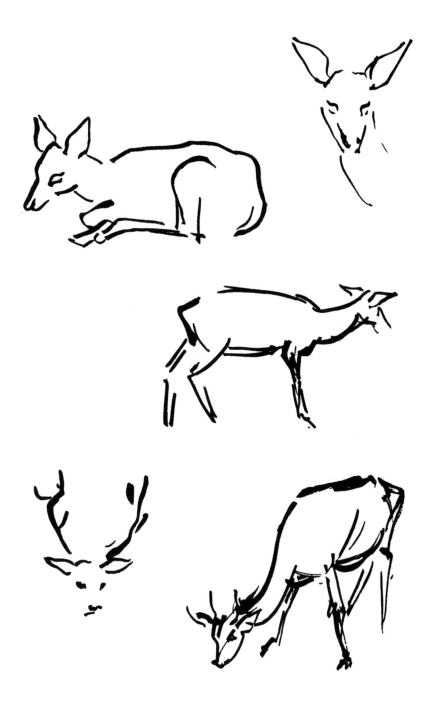

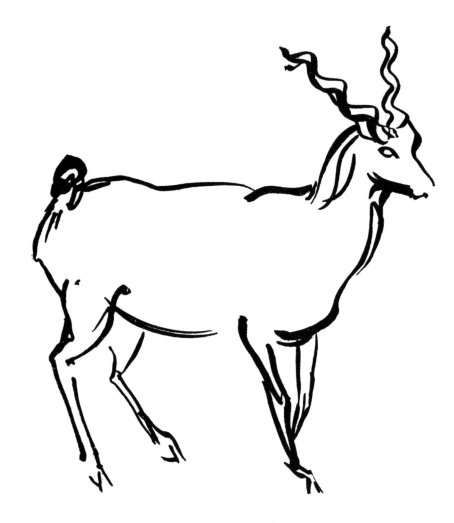

[ 37 ]

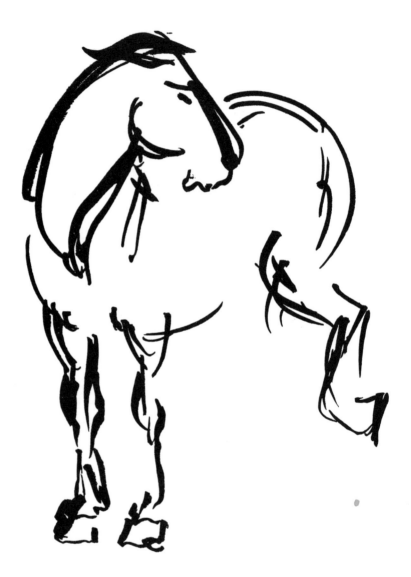

[ 38 ]

Watching the horse move, note where the joints are, in which direction they bend, what type of joints they must be to permit that particular sort of motion.

Note what the other three legs are doing when one leg is doing a certain thing, what the tail is doing, whether the head sways, whether the body goes through some sort of motion. Study the different gaits of an animal, the walk, the trot, the gallop. How a horse, for instance, changes from one to the other as his speed varies. Observe closely some equestrian statues. Are all the legs doing the same thing? Or are the fore legs trotting and the hind legs at a standstill?

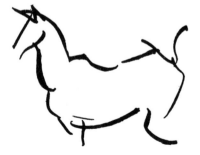

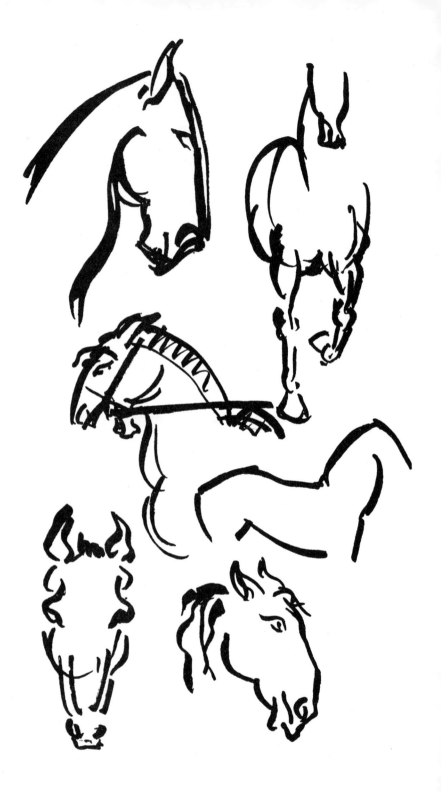

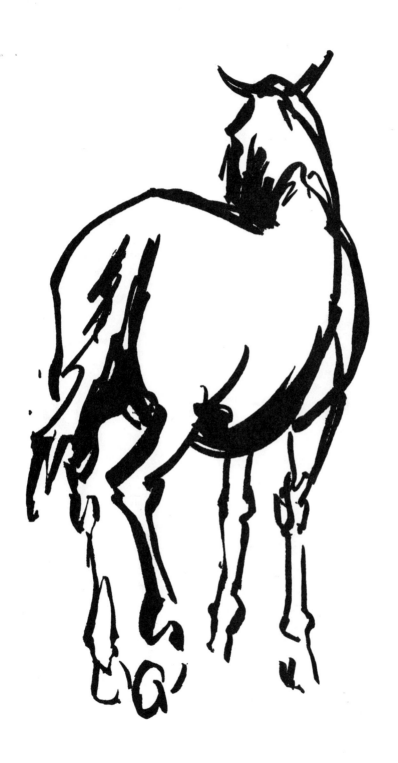

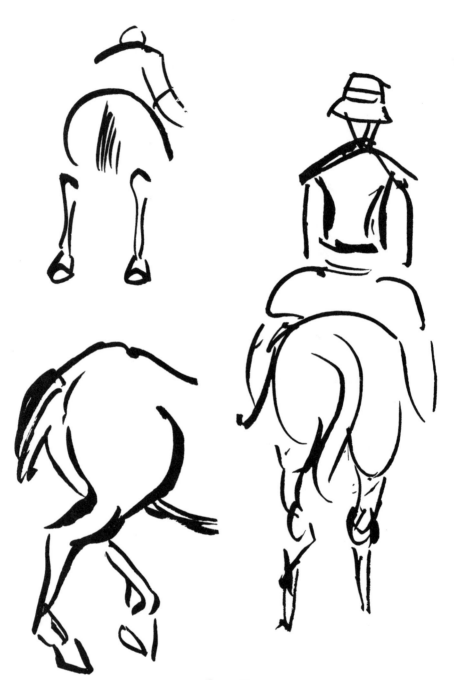

Caricature is an effective means of study. A caricature emphasizes the characteristic features, whatever they may be, without regard to the variety of the model. However, don't let caricature gain control of all your drawings. Caricature the action as well as the animal.

When in doubt as to joints, work out your problem by analogy to the human skeleton, when possible. Many animals' skeletons correspond closely to the human frame. Be conscious of the muscles in all parts of the body. They make all the big lines convex. Constant activity is the best prescription for any sort of drawing. Carry pencil and paper with you at all times. And use them. Don't be self-conscious.

Draw in public conveyances. There will be nothing but people there, but if you think about it you will decide that most of them look like some sort of animal. Study them intensely and discover what feature or action of theirs it is that suggests the animal. Then draw them, making them look more like the animal than ever.

[ 44 ]

# ⟋ POSE ⟍

The pose, or rather, lack of pose of the animal will often prove a disturbing element. Sometimes the beast will be reclining, probably asleep. Then, unless he is in the throes of a nightmare, it will be easy sailing, provided you can get a good vantage point. However, if he is on the move there may still be two possibilities. The animal may be repeating a certain cycle of motions, as a caged lion paces back and forth, or it may perform the action only once, as a dog may yawn. In the first case it is possible to wait and observe and study the action, thus building up one's knowledge by repeated views of the same thing. In the second instance, memory and "impressionableness" come into play very strongly, as well as ease and speed of execution.

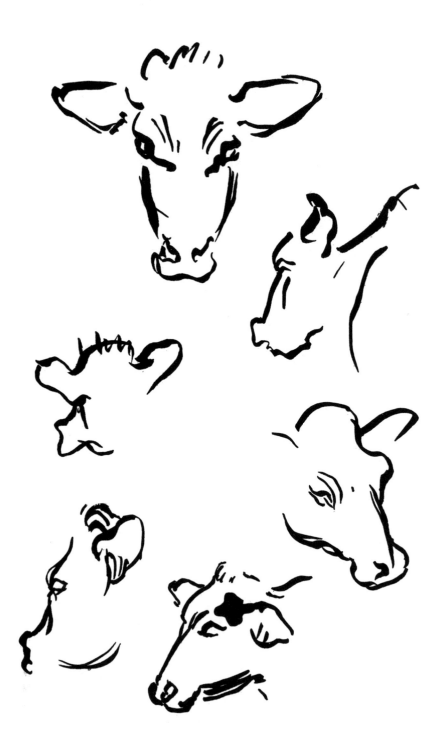

# ✐ COWS ✐

The cow is a languid, long suffering animal, yet when worried by a dog she frequently shows great activity. That a bull can move rapidly everybody knows who has been chased by one. The cow's movements while comparatively slow are invariably graceful. Because cows are to be found wherever there is open country, there are plenty of opportunities to sketch them. Being commonplace, however, they are sadly neglected, like the old-fashioned chaperone. The study of any domestic animal helps in drawing the rarer and wilder ones, and it behooves the student to spend as much time as possible in sketching cows. Cows are torn between two emotions, timidity and curiosity. They will advance haltingly to where you are quietly sketching, but after a contemptuous and fragrant sniff, usually they will walk away again. Cows make splendid and inexpensive models.

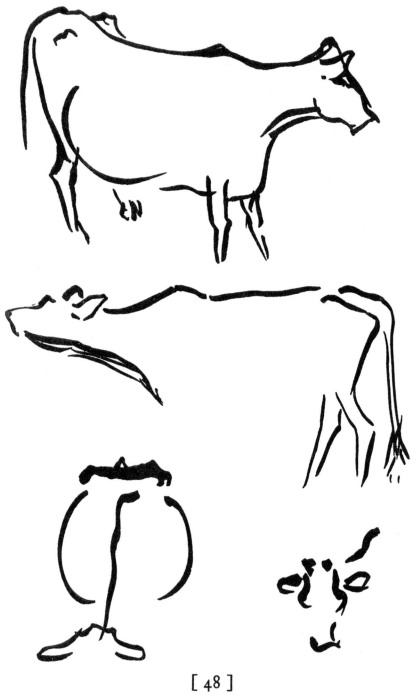

[ 48 ]

The use of photographs may often be necessary when a specimen is unavailable. More than one photo is, however, highly desirable, as photos are often misleading as to essential features. A few views at different angles will be found advisable.

Resources offered by the Museums of Natural History will often be found convenient. Skeletons are excellent. But stuffed specimens are somewhat subject to error, tho many are good. The element of form is likely to be more accurate than that of action. Reconstructions must be accepted cautiously.

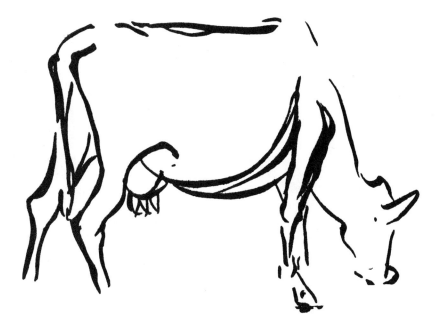

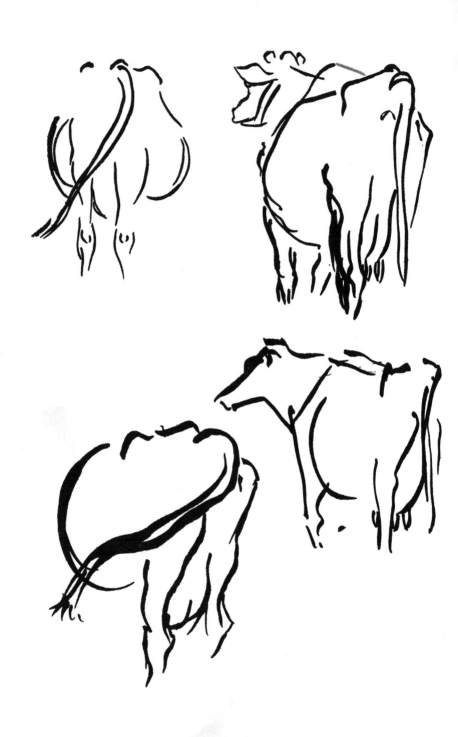

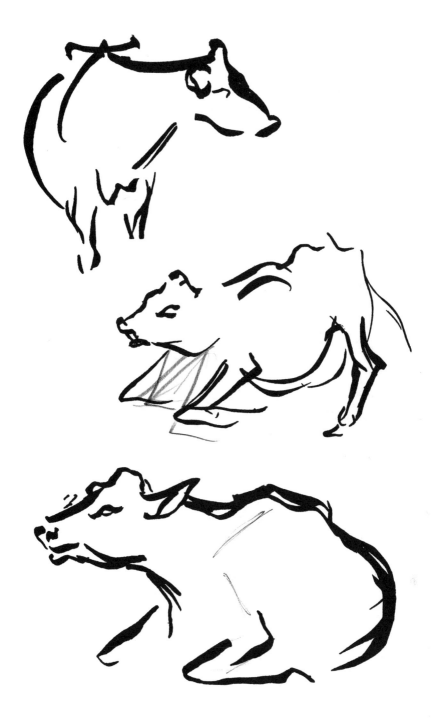

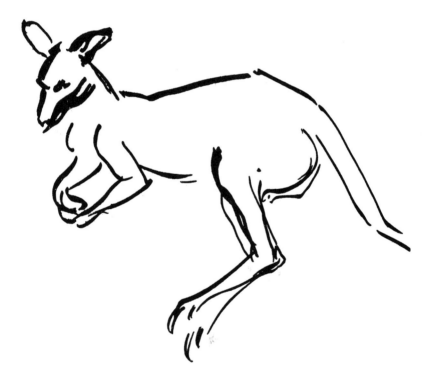

[ 52 ]

# ⚘ ANIMAL INSTINCT ⚘

In drawing animals we must have the feeling that they are doing something, no matter how simple the thing may be. In spite of our vast mental superiority, animals have minds and use them. In man, reason has taken the place of instinct to a great extent. Animals think with their bodies to a greater extent than man does. In anger or fright, ears flatten against the head, the hair along the spine rises. The dog at sight of food drools at the mouth, male birds courting display their feathers. There is no self-consciousness: animals are always intent upon the thing they are doing, and we must feel that they are as we sketch them.

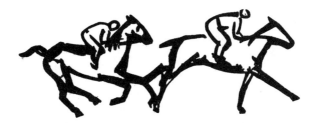

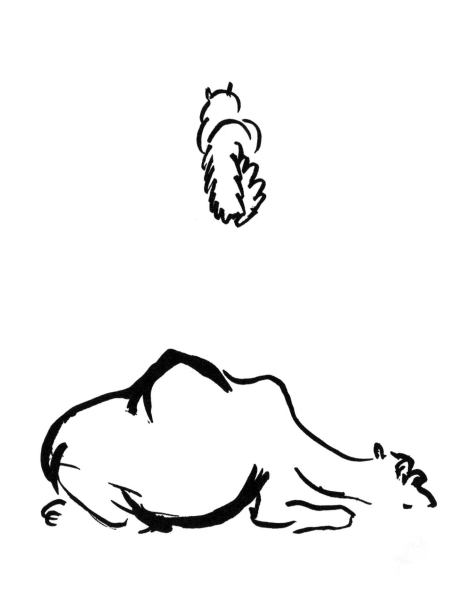

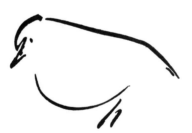

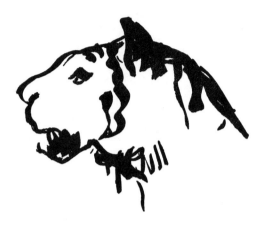

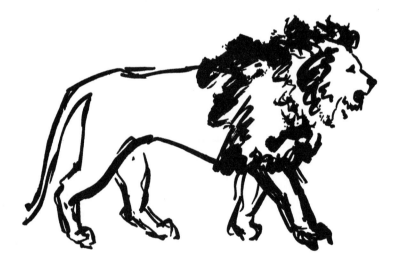

# ⸙ THE LION ⸙

When at the zoo we hear noises in the lion
house we hasten there to hear the lion roar.
We marvel at the tireless energy of the King
of Beasts and his lioness pacing before the
bars. How kingly and courageous they seem
whenever we see them. Even in the circus
where they supposedly are tamed, they seem
ever to be on the very verge of breaking loose.
In drawing the lion or lioness and even the
leopard and leopardess we find a most coura-
geous instinct to portray.

We hope that the object of this book,
which really is to create a stimulant to the
younger artist, to draw things as he sees them,
has fulfilled its purpose. Always remember
that the eye and brain should work in perfect
coördination and that drawing is an absolute
mental process of perfecting this mutual
understanding.

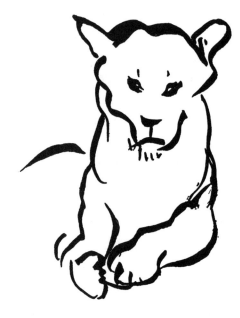

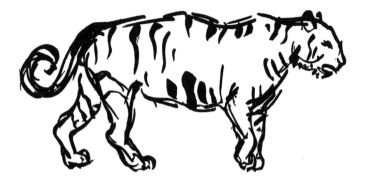

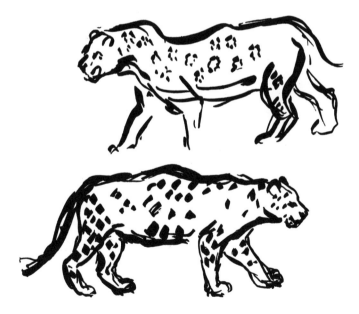

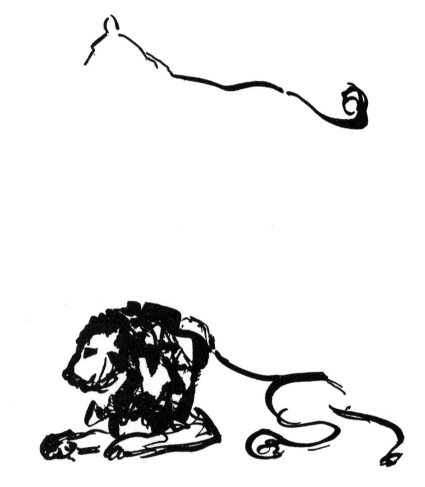

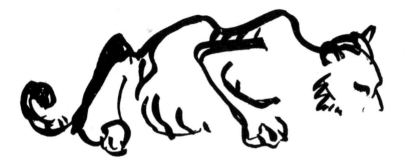

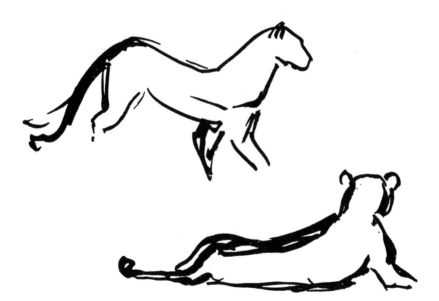

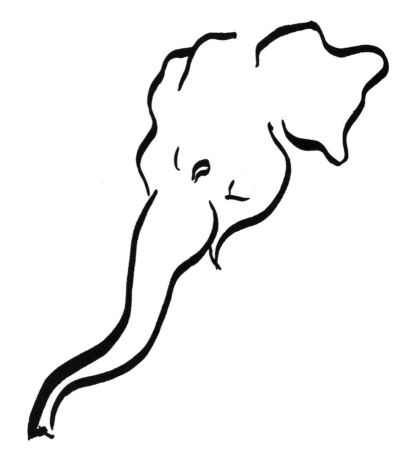